ARDENNE D'ARENSBOURG DARGIN DARIEAN D'ARMOND DAROUSSE
ARTOIS DARVY DAUPHIN DA... DAVID DAVET DE BATES
E BEAU DE BESSONNET DEBETA... EUX DE BOIS-
ANC DE BOSE DE BRETON ...ET DECONGE
COTEAU DE COUX DEDEAUX ...DEGUETAIRE
E JAIFFE DE LA CROIX DELAFOSSE ... VE DELAMBRE
LANOIX DELAPASSE DELARODERIE DELAS DE LATIN DELATTE
LAUNE DELAVILLE DELCAMBRE DELERY DELHOMME DEMAREST
MARIE ...T DEMOULIN
MOUY ... E DEROCHE
ROUEN ...S GRAVELLES
SJARDINS DES... ...ALL DE VAUX
VILLE DEVIL... DICHARRY DIDIER DOIRON DOMENGEAUX
MINGUE DOMINIQUE DONAT DORNIER DOUCET DOUGET DOURIS-
AU DOURRIEU DOUTRIVE DOUZAT DRANGUET DU BOIS DU BOSE
BROC DUBUISSON DU CHAMP DUCHARME DUCHIEN DUCREST
FRENE DUFROCQ DUGAS DUGAZON DUHON DUMAISTRE DUMAS
MONT DU MOULIN DUPAQUIER DUPAS DUPLANTIER DUPLANTIS
PLECHIN DUPLESSIS DUPONT DUPRE DUPUIS DUPUY DURAND
ROCHER EASTIN EDOUARD ELIE ELISSALDE ELLOIS ENAULT
GLADE ENSENAT EPHRON ESCUDIER ESNARD ESNAULT ESTEVIN
IENNE EYMA... ...OUST FANGUY
UCETTE FA... ...T FERCHAUD
RIELLE FILL... ...INE FONTENOT
RET FORNA... ...NET FOURNIER
URRIER FO... ...OIS FRANELIN
ENEAUX FE... ...YOU FUSELIER
SON GABOU... ...NEUX GAGNON
IENNIE GA... ...LET GALLIEN
LLIER GARI... ...UET GASTINEL
AUBERT GA... ...EAUX GENRE
NTILES GIE... ...AIR GISCLARD
BERT GONS... ...ND GOUDEAU
UGEON GO... E GRANDJEAN
ANGER GR... E GREMILLION
ENIER GROS... MARD GUICHET
IDROZ GUI... ME GUILLORY
ILLOT GUIR... UR HARLEAUX
YDEL HEB... LIER HONORE
RVILLEUR ... EAU JARREAU
UBERT JEA... RION JOLIBOIS
LISSAINT JO... JUDICE JUGE
LAIS JULIEN... UNEAU JUNOT
STILLIEN KU... HE LABASQUE

Nous Sommes Acadiens
WE ARE ACADIANS

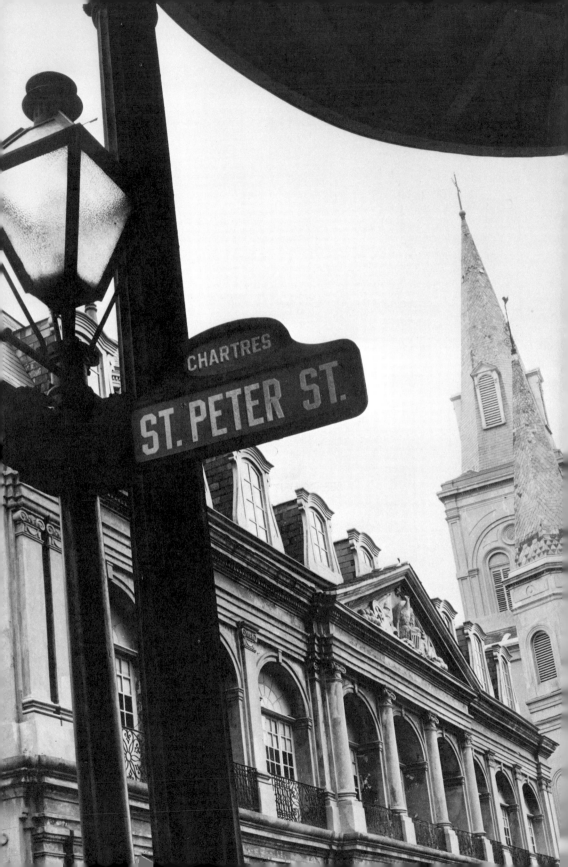

Nous Sommes Acadiens
WE ARE ACADIANS

Myron Tassin

Photography by Fonville Winans

PELICAN PUBLISHING COMPANY

GRETNA 1976

Copyright © 1976 by Myron Tassin
Photographs © 1976 by Fonville Winans
All rights reserved

Library of Congress Cataloging in Publication Data

Tassin, Myron.
 Nous sommes Acadiens—We are Acadians.

 1. Cajuns. I. Winans, Fonville. II. Title.
III. We are Acadians.
F380.A2T37 976.3′004′046 76–25036
ISBN 0–88289–117–0

Manufactured in the United States of America

Designed by Gerald Bower

Published by Pelican Publishing Company, Inc.
630 Burmaster Street, Gretna, Louisiana 70053

To my father, Pliny Tassin (1895–1975), a proud, practicing Acadian who was so imbued with his unique "nationality" that he was forever referring to non-Acadians as "les Americains."

Contents

Acknowledgments

To *Fonville Winans*, for his art.

To *J. Perry Brandao (Jean-Pierre Brandaux)*, for his contributions in the foreword and epilogue.

To *Mrs. Leona Martin Guirard*, Curator for thirteen years of the Acadian Museum in Saint Martinville, for her wise, enthusiastic, and unswerving counsel.

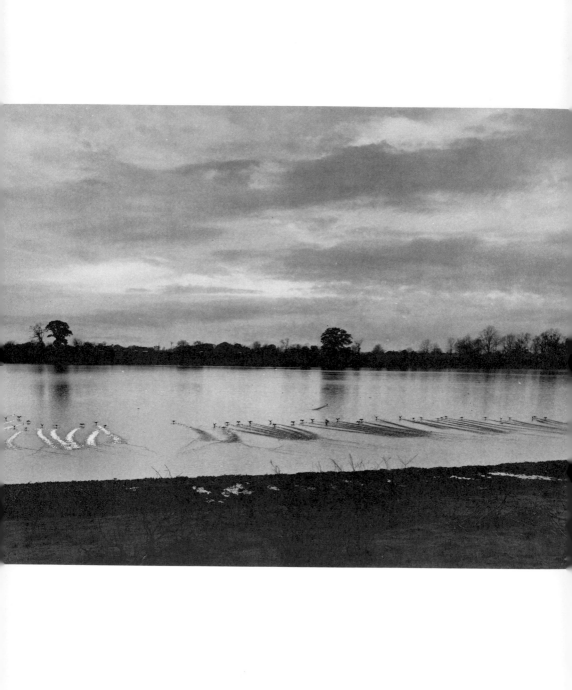

Introduction to the Photographer

Fonville Winans is a maverick, eccentric, award-winning artist who paints with his eye, sculpts with his lens. With an abundance of "moxie" (as he likes to call a sixth sense that often graces an inquisitive, inventive mind), he spent much of the Depression period of the early 1930s recording the folkways and mores of the people of Acadiana.

With a facility for prying into things, the Baton Rouge photographer soon learned well the mystique of the Acadian philosophy: "Work hard and coast long," as his photos graphically attest.

In organizing this book, I gave serious consideration to documenting the Acadians' recent phenomenal achievements with up-to-date photographs, but decided instead to relegate that charge to the copy. Fonville's style and quality are so overpowering that the contrast with contemporary photos would be distracting.

While some of the subjects in this book may not be true Acadians, they lived or live in Acadianland. Thus they have been adopted with open arms into the Acadian way of life through geographic circumstance. Besides, they serve well to dramatize the story line.

Myron Tassin

ACADIAN TOWNS AND PLACES

NEW IBERIA LAKE CHARLES LAFAYETTE OPELOUSAS CAMERON CREOLE HACKBERRY GRAND CHENIER PECAN ISLAND WELSH JENNINGS LAKE ARTHUR GUEYDON ABBEVILLE ERATH DELCAMBRE HENRY ESTER RICEVILLE CROWLEY MERMENTAU EVANGELINE IOTA EGAN EUNICE LAWTEL RICHARD CHURCH POINT RAYNE DUSON MAURICE INDIAN BAYOU ANDREW LEROY MIDLAND ESTERWOOD MORSE LYONS POINT LACASSINE MAXIE BRANCHE BASILE ELTON MORGAN CITY BERWICK BAYOU VISTA PATTERSON CENTERVILLE GARDEN CITY FRANKLIN BALDWIN CHARENTON GLENCO ADELINE SORRELL JEANERETTE LOISEL OLIVIER PEEBLES LYDIA AVERY ISLAND JEFFERSON ISLAND YOUNGSVILLE MILTON BROUSSARD BURKE CADE MORBIHAN LOREAU-VILLE SAINT MARTINVILLE CAROLINE ISLE LABBE SAINT JOHN PARKS RUTH BREAUX BRIDGE MAMOU VIDRINE POINT BLUE CHATAIGNER ANDREPONT VILLE PLATTE WASHINGTON PORT BARRE SUNSET GRAND COTEAU ARNAUDVILLE CARENCRO SCOTT OSSUN LONGBRIDGE COTTONPORT LA JUNCTION HICKORY BACK STEP POTATOVILLE MOREAUVILLE BORDELONVILLE BIG BEND PETITE COTTES MANSURA LA GRANDE ECORE BOUT DU BAYOU HESSMER FIFTH FARD MARKS-VILLE GOUDEAU BAYOU SAUVAGE NORTH CRAQUEVILLE SOUTH CRAQUEVILLE BAYOU BLANC DORA EVERGREEN CHEZ DENIS LACOUR NEW ROADS HAMBURG BATON ROUGE DUPONT JARREAU ROUGON LAKELAND LIVONIA MARINGOUIN ROSEDALE BAYOU BLEU TROU DE TIGRE LE LARGE LA POINTE A SELTZ BRUSLY PLAQUEMINE ADDIS PORT ALLEN GROSSE TETE WHITE CASTLE DONALDSONVILLE GRAND BAYOU KLOTZVILLE PIERRE PART PAINCOURTVILLE NAPOLEONVILLE SUPREME LABADIEVILLE THIBODAUX LAFOURCHE SCHRIEVER RACE-LAND BAYOU CANE HOUMA LOCKPORT PRESQUE ISLE BOURG MONTEGUT CHAUVIN VALENTINE LAROSE CUT OFF GALLIANO GOLDEN MEADOW GRAND ISLE PRAIRIEVILLE GONZALES SAINT AMANT FRENCH SETTLEMENT SORRENTO HYMEL CONVENT LUTCHER REMY GRAMERCY VACHERIE GARYVILLE RESERVE EDGARD LAPLACE HAHNVILLE LULING HARAHAN WESTWEGO MARRERO LA NOUVELLE ORLEANS GRETNA LAFITTE GAROPHIER WHISKEY BAY HAPPYTOWN TETE D'ISLE

Foreword

Oh, how I wish I were a Cajun. I really do.

I wish I were a descendant of those sturdy pioneers whose destiny led them from France to Acadia in Canada and then to South Louisiana. But my ancestors were totally European, and although my name is thoroughly French, all I can truthfully claim to be is an "imported Cajun" rather than the genuine article.

Nevertheless, being an imported Cajun is a warm experience in itself. For in typical fashion, the wonderful Acadian people of South Louisiana have accepted me as one of their own. In fact, they have certified my status with a "passeporte" into Acadiana, granting me honorary Cajun citizenship, "with all the rights, privileges, and responsibilities thereunto appertaining."

If you come to South Louisiana, the Cajuns, in their cheerful, hospitable fashion, will make you welcome among them also. You don't need to speak French or have a French-sounding name. Happily, no formal credentials are required. The printed "passeporte" business is just a joke—part of the Cajun humor.

As a matter of fact, formalities of any kind are rare among these easygoing people. They just want you to visit them, and "pass a good time" with them. So come. Their warm hearts and exuberant spirit will give you an experience you'll never forget.

To get to know the Acadians better—either before, during, or after your visit among them—you simply must read *Nous Sommes Acadiens / We Are Acadians*. (Because there are several ways to say "We are Acadians," in varying local dialects, the author elected to use French in the title. It is, after all, the trunk for all of the Acadian patois

branches.) In this little volume, my long-time friend Myron Tassin has put together a marvelous documentary on the Acadian people. A "24-carat Cajun" himself, he knows, understands, and loves his Louisiana Acadian people. And to the great benefit of those who read his book, he has a sensitive capacity for communicating a great deal of the mystique that makes the Cajuns what they are.

Of course, Fonville Winans' magnificent pictures speak for themselves. But with just a touch of musical narrative, Tassin has made them sing.

So when you look and read, find a nice quiet place—and you, too, can hear the song. After you have heard it, as I have, you will join me in saying, Oh, how I wish I were a Cajun. I really do.

Jean-Pierre Brandaux

Nous Sommes Acadiens
WE ARE ACADIANS

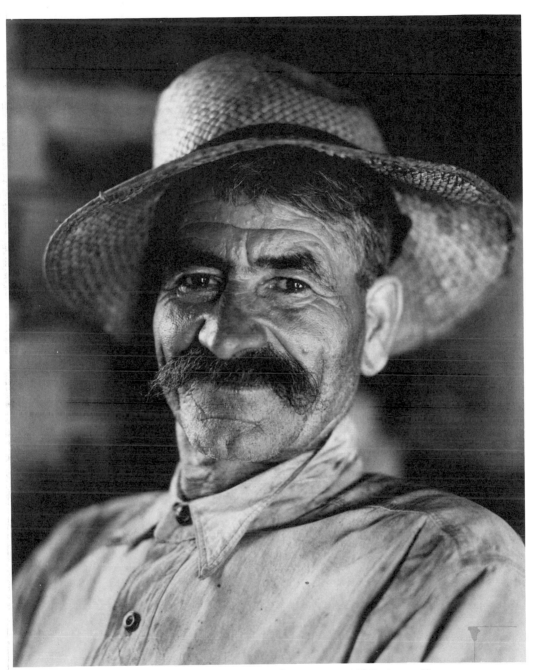

We are Acadians—probably better known as "Cajuns."

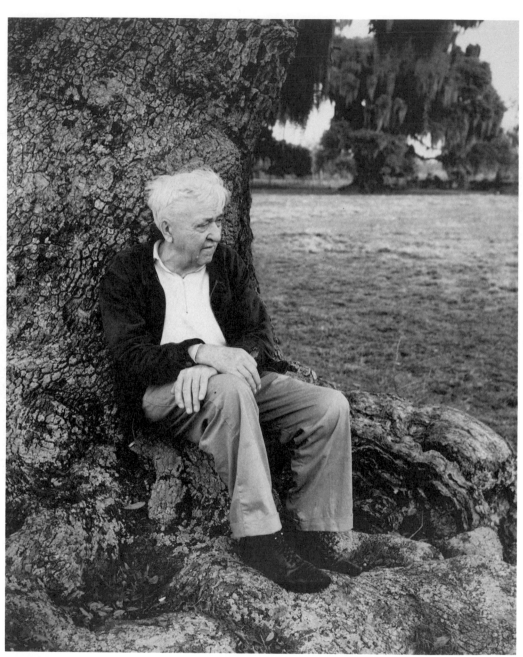

Being Acadian makes us unique . . .

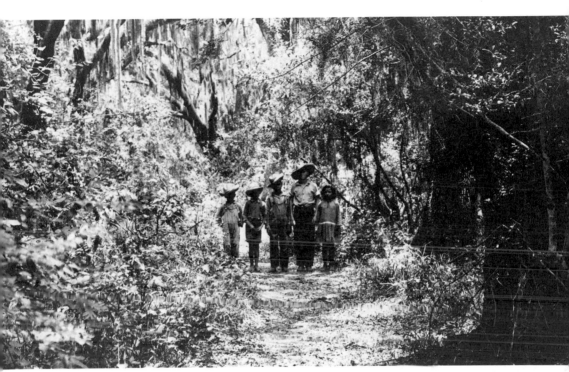

unique because our roots have been planted on two con-
tinents and in three countries.

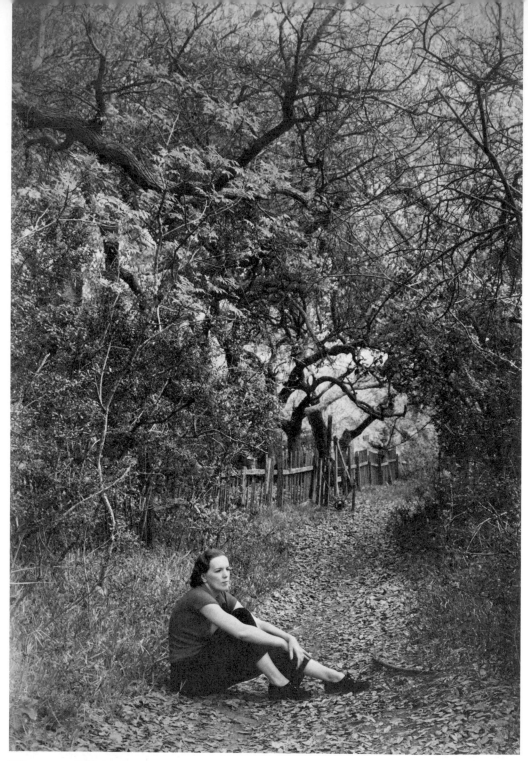

First, as Vikings, we settled in western France.

Then we were transplanted across the Atlantic in Acadie, Canada (Nova Scotia).

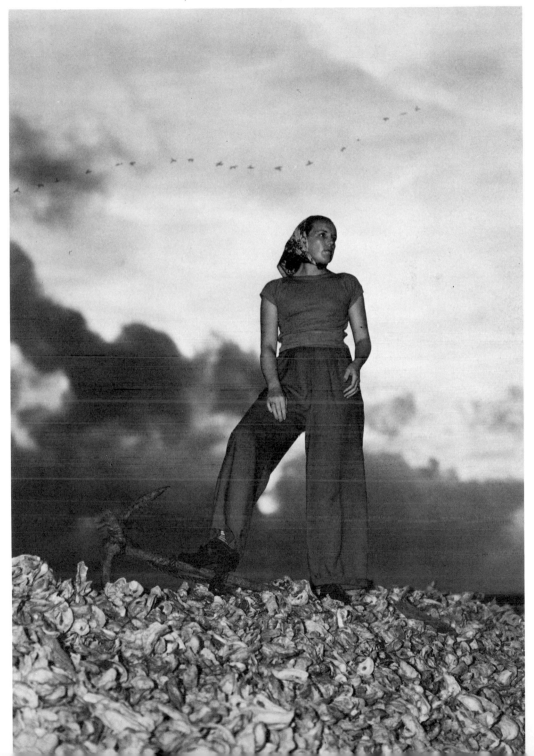

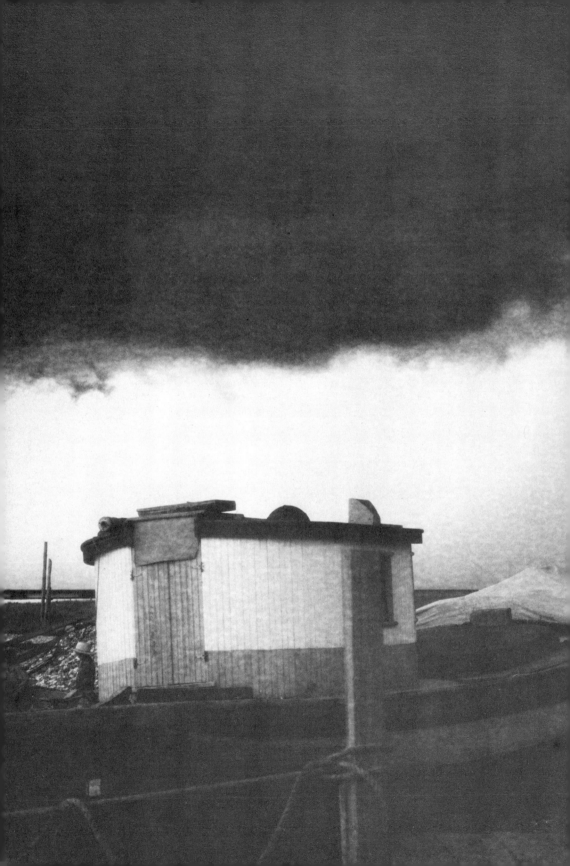

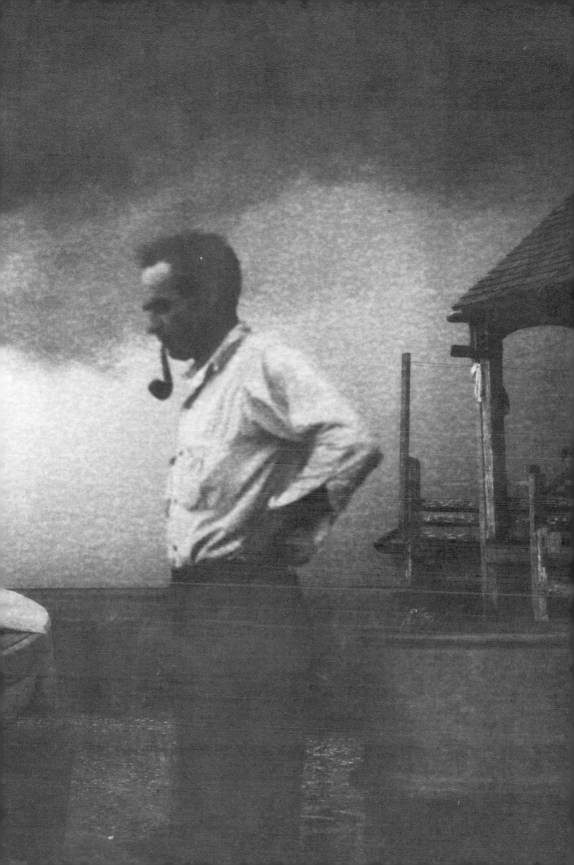

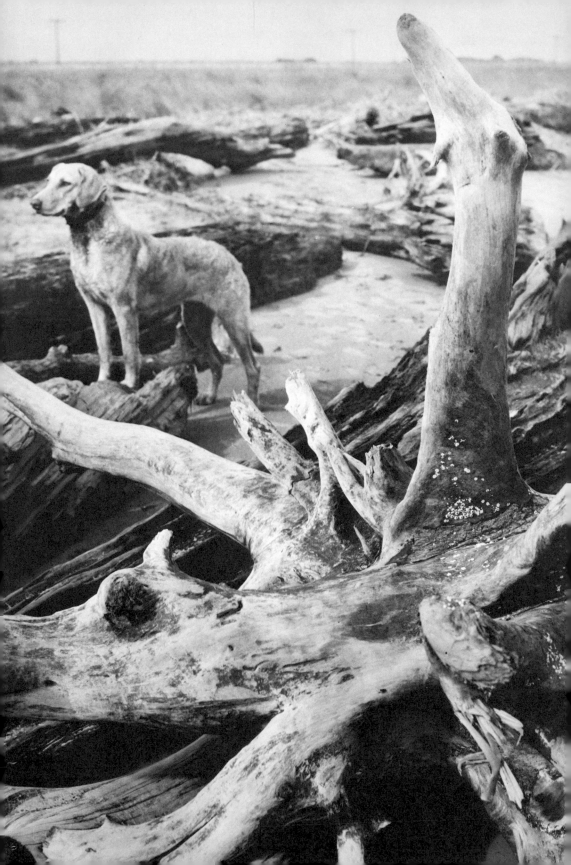

When British occupation forces in 1755 tried to extract an oath of allegiance to the crown of England, about ten thousand of our forefathers who refused were herded aboard ships and sentenced into exile.

After ten years of hardship and servitude, for the most part along the U.S. Atlantic coast, the more adventurous among us migrated to New Orleans, already a flourishing French city.

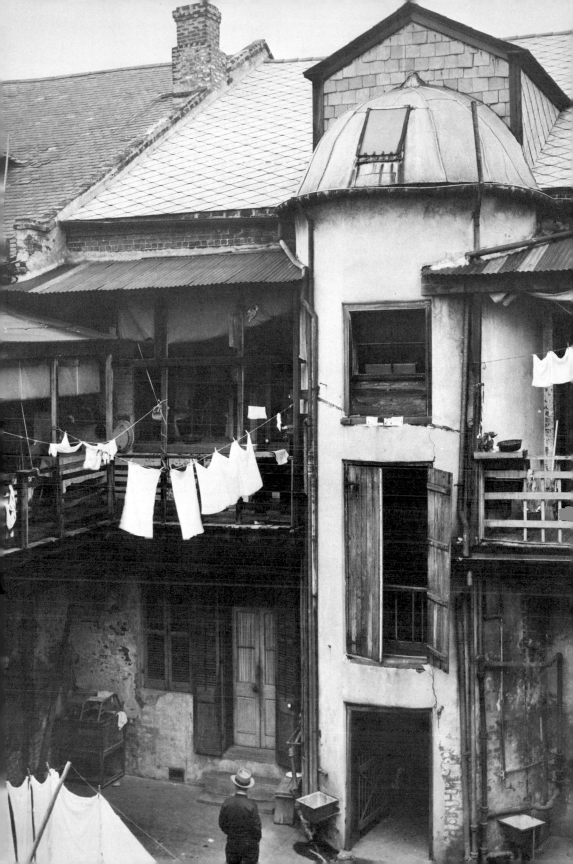

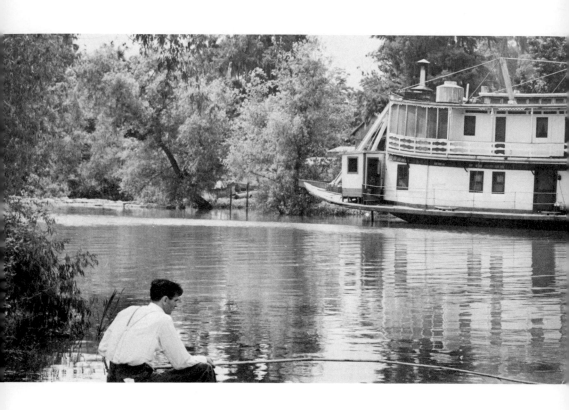

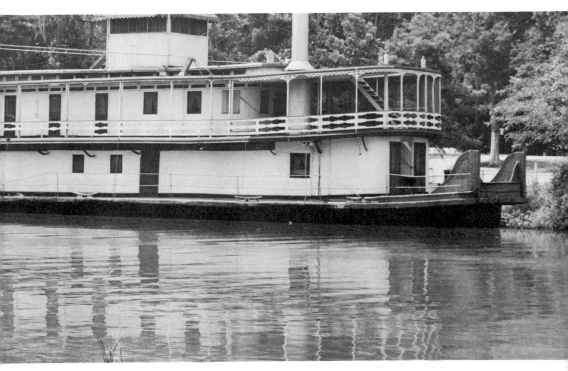

A few of us stayed there, in the "Paris of the West," but most of us moved on to settle north and west of the big city . . .

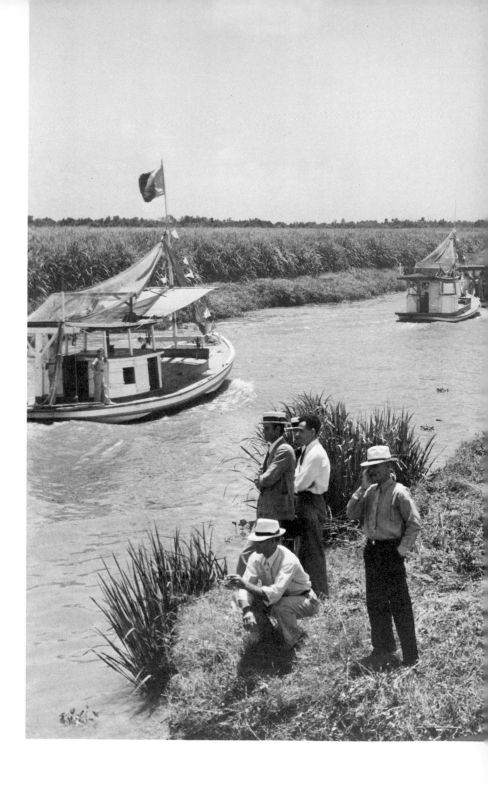

along the rivers and bayous

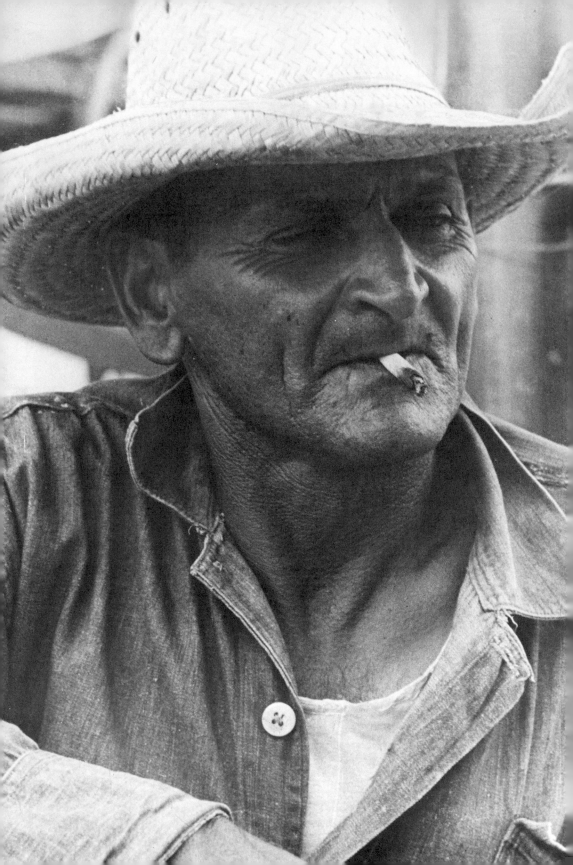

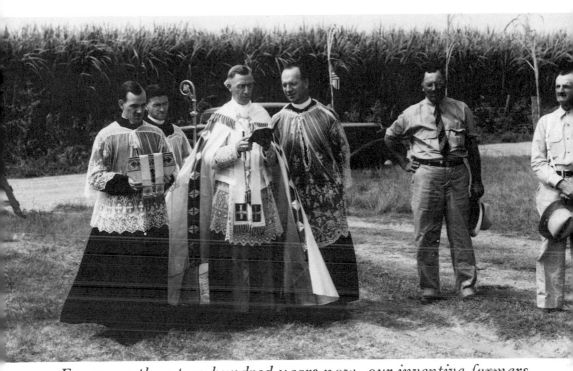

For more than two hundred years now, our inventive farmers have been reaping bountiful crops

from the rich alluvial soil . . .

vegetables from generous, verdant gardens.

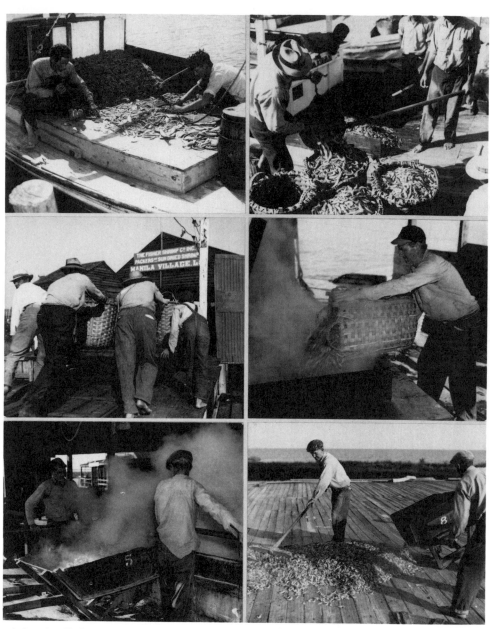

Adroit fishermen extract brimming catches from our teeming estuarian waters,

and expert marksmen harvest from a cornucopia of wildlife.

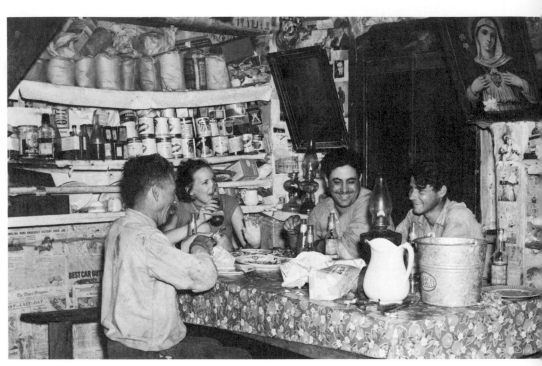

*The largesse of Providence finds its way to our crowded tables
. . . after masterful enhancement in an incomparable,
delectable Cajun cuisine:*

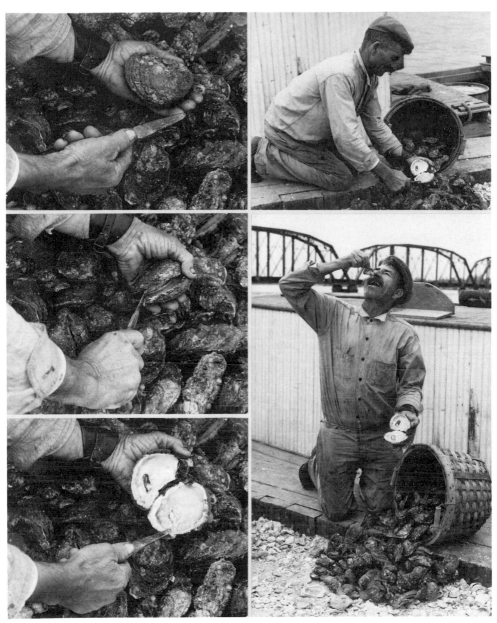

étouffée, fricassée, bisque, rôti, sauce piquante, gumbo, jambalaya . . .

Our faces, like our music, songs, and litera-ture, are moving.

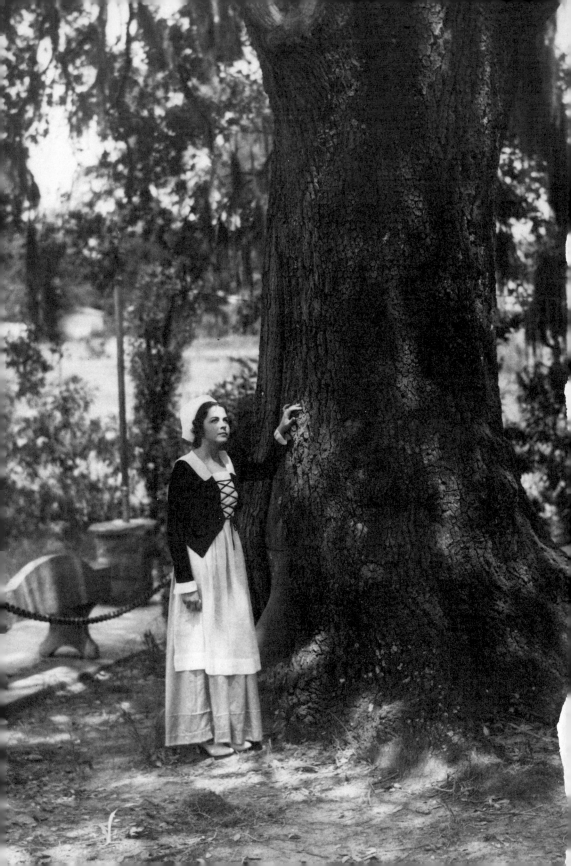

Like Longfellow's "Evangeline," they tell of long separation of loved ones, heartbreak, hardship.

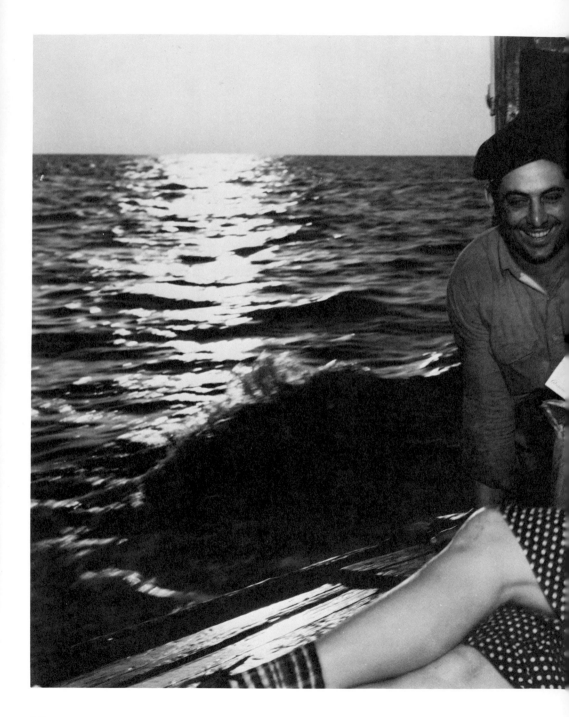

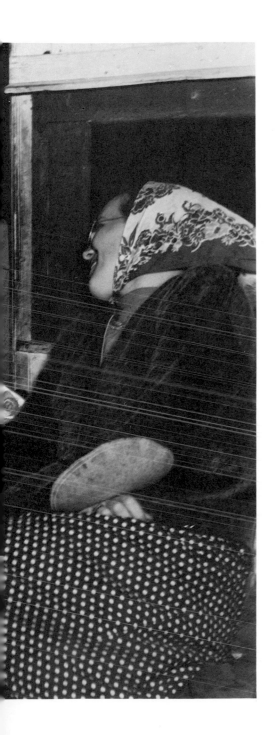

But they tell, too, of true love, friendship, neighbor-liness, coming home, success.

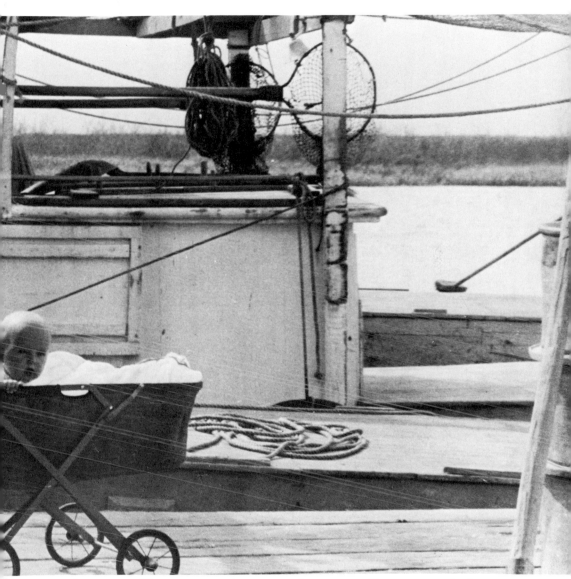

To each succeeding generation, our faces confirm an undying optimism fashioned out of our Canadian exodus:

Saute, crapaud, ta queue va brûler;
Prends courage, elle va repousser!

Jump, frog, your tail will burn;
Take courage, it shall return (grow back)!

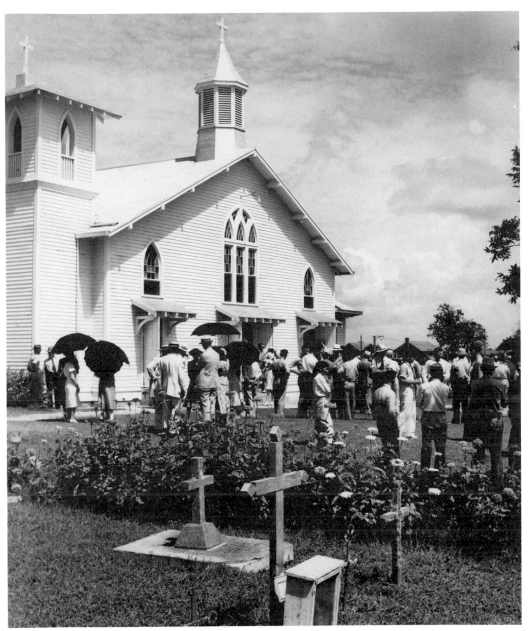

Our optimism is borne out of a deep, abiding faith. Our Christian way of life is heavily accented with mutual assistance . . .

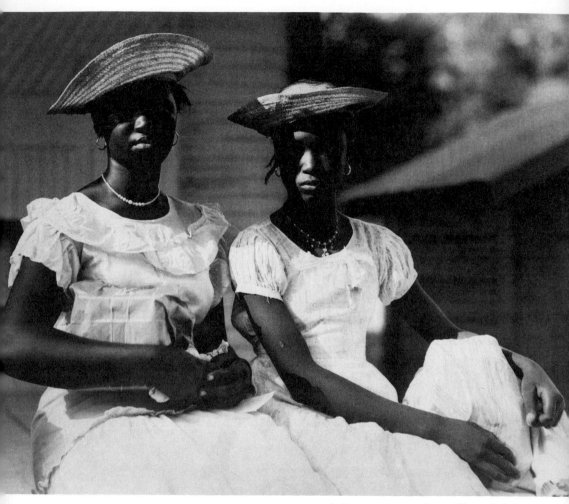

with concern for all neighbors.

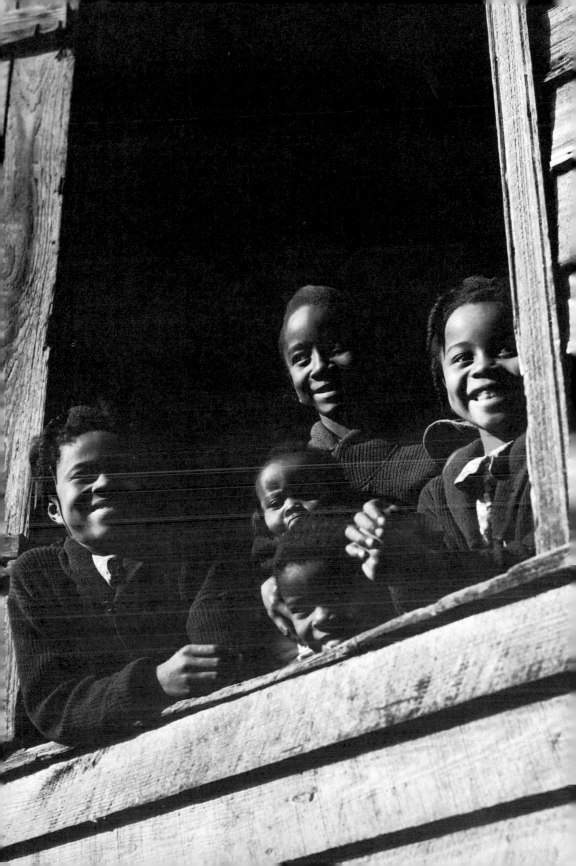

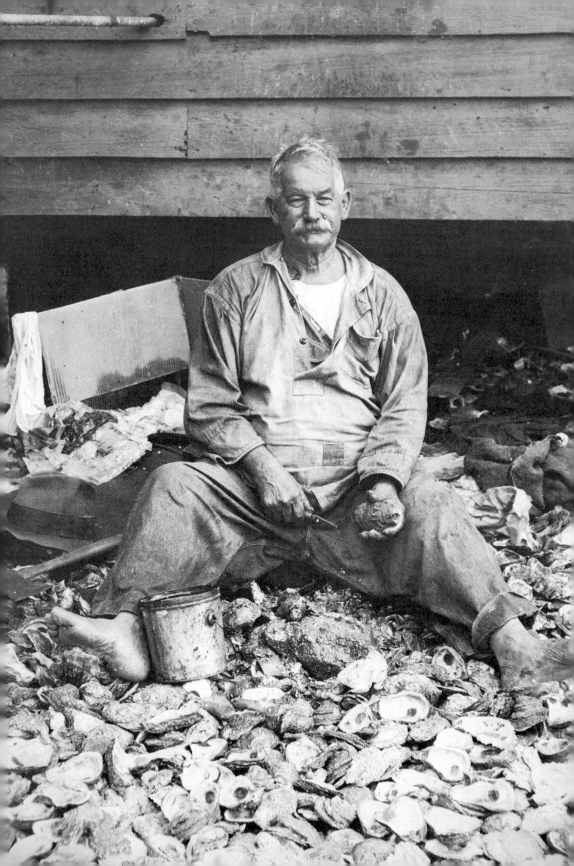

As to common, everyday problems—most of us are free spirits who "don't give a doggone."

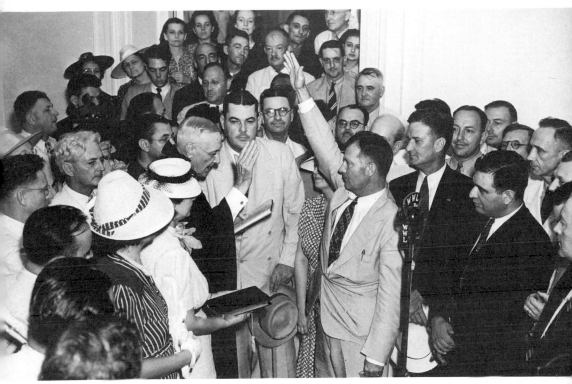

We overcame the political turmoil of the 1930s . . .

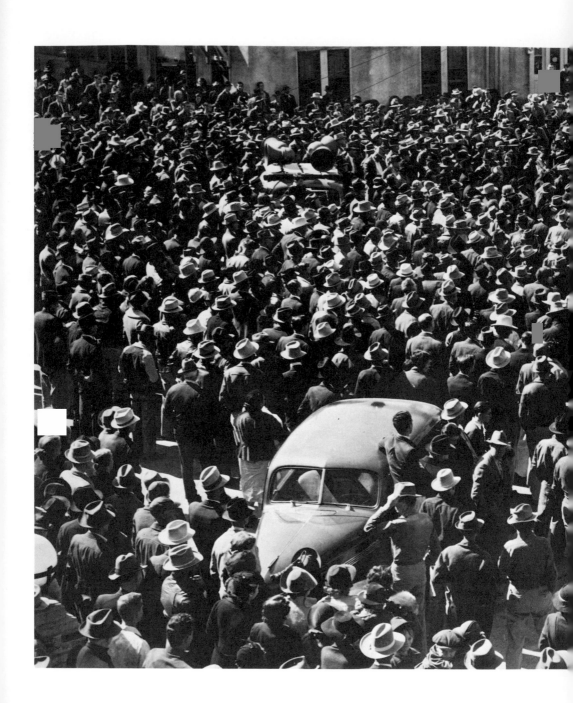

60

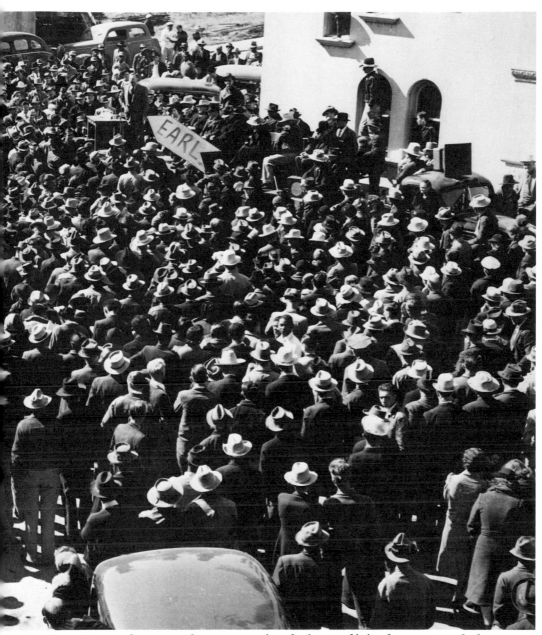

and supported men who recognized the political power of the little people.

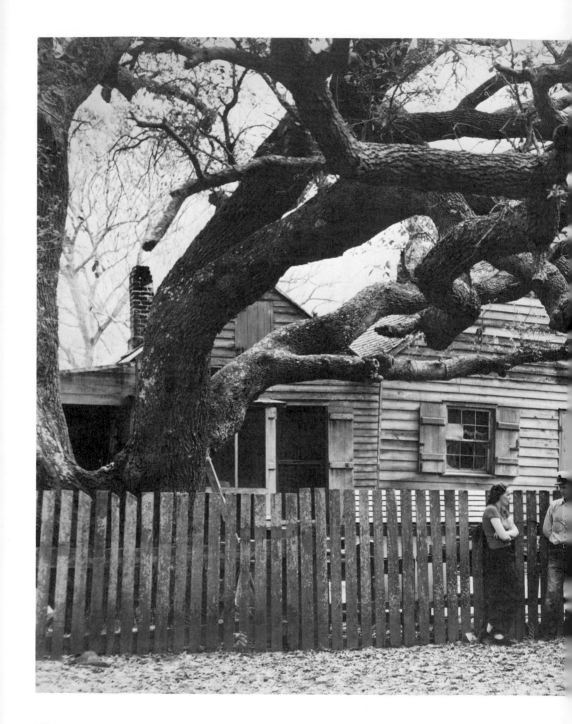

*The language we speak comes
from one trunk: the
French spoken in our
motherland during the
seventeenth century.
Sometimes we borrow
words from our English-
speaking neighbors, and
they laugh at our home-
grown, patchwork patois
that has branched out
in various directions
through the years.*

Monsieur Olivére
A parti en guerre

Avec son égalère
Dans sa poche en arrière.

Il a sauté la barrière
* par en arrière,*

Et il s'est enfonce d'un
* piquet de barrière*
Dans le derrière . . .

De sa chemise!

Mr. Oliver
Went to war

With his carpenter's planer
In his back pocket.

Over the back fence
he did sail,

And a fence picket
stuck him
Squarely in the tail . . .

Of his shirt!

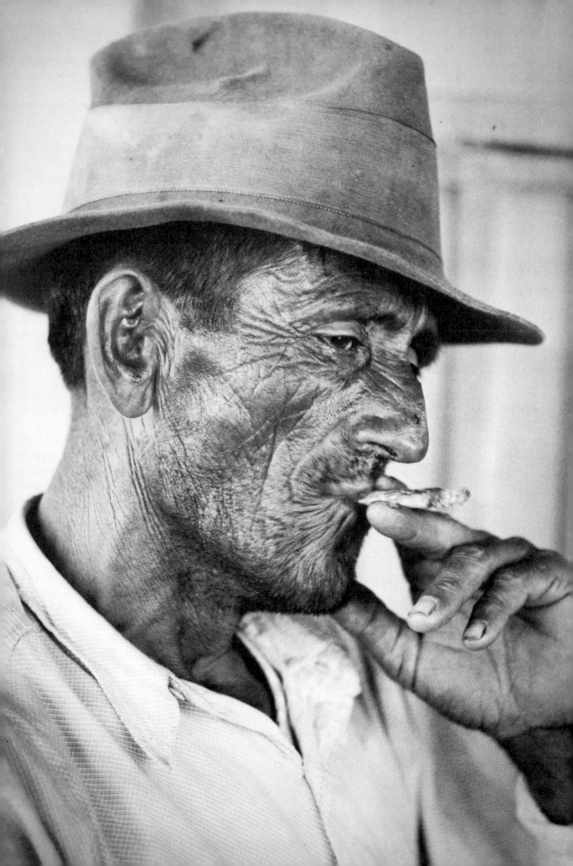

Our faces tell you that we work hard . . . on oil rigs in the Gulf of Mexico, the Amazon, the North Sea . . . in rice, sugarcane, soybean, and cotton fields.

We work hard so that our children can become leaders of Louisiana's government, its professions, businesses, labor, farming, industry.

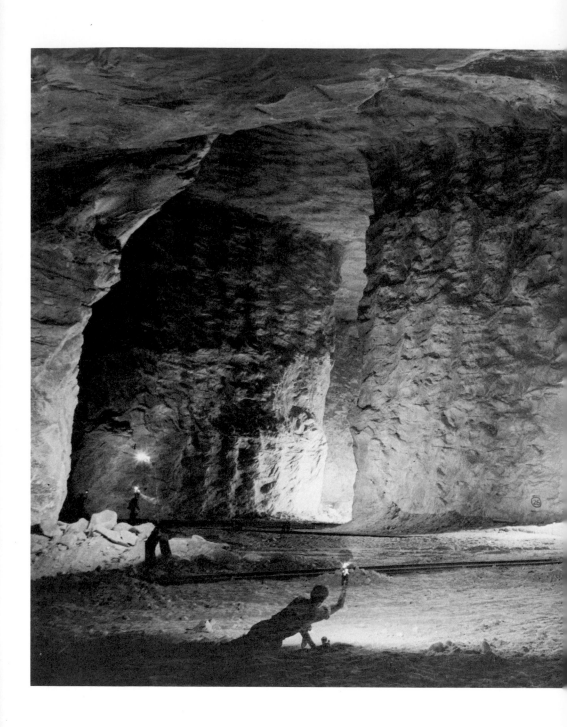

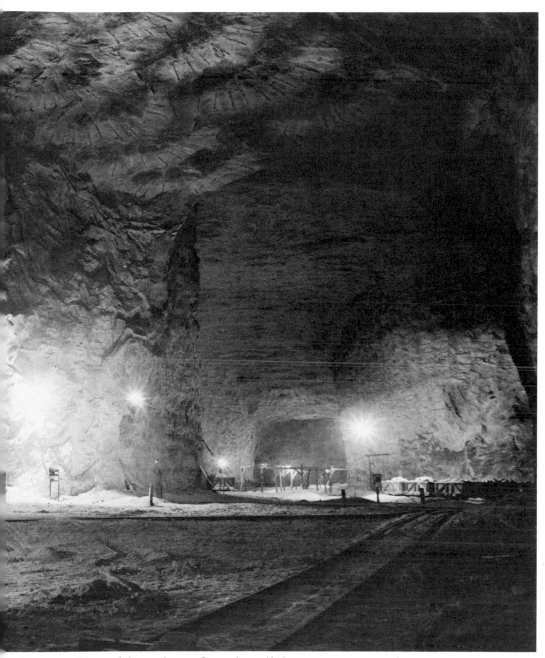

To us, "working the salt mines" is an opportunity, not a cross.

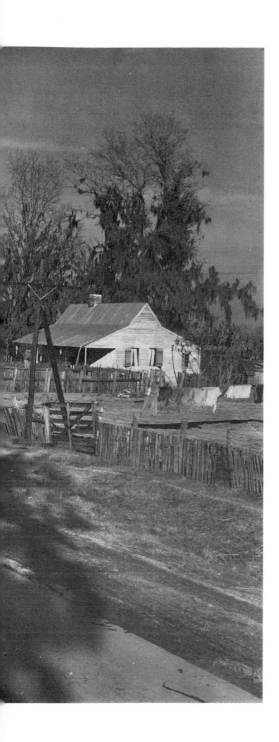

Many of us have left the farms
and villages for the
city . . .

but we have not left our
Acadian ways behind.

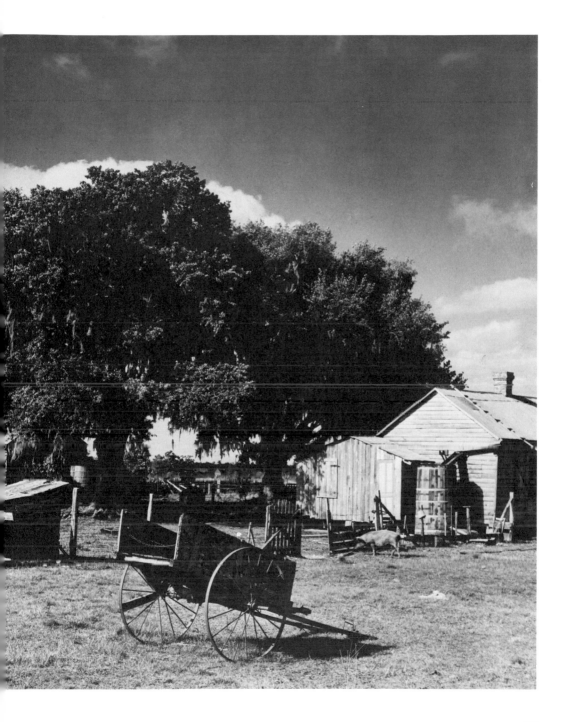

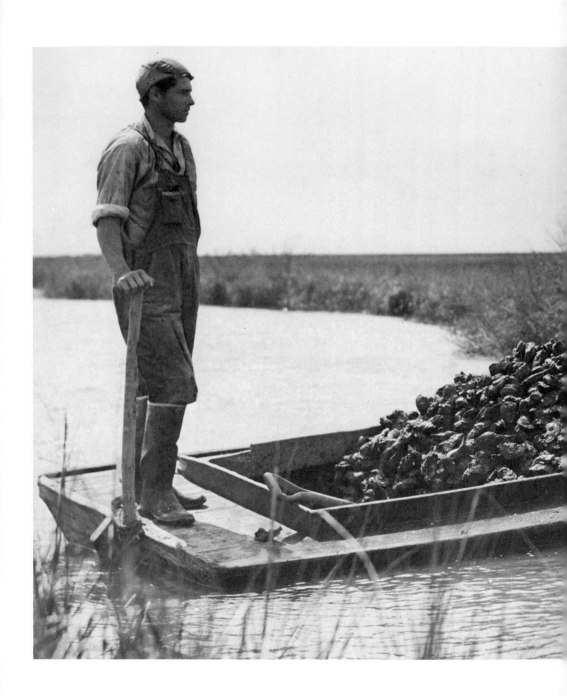

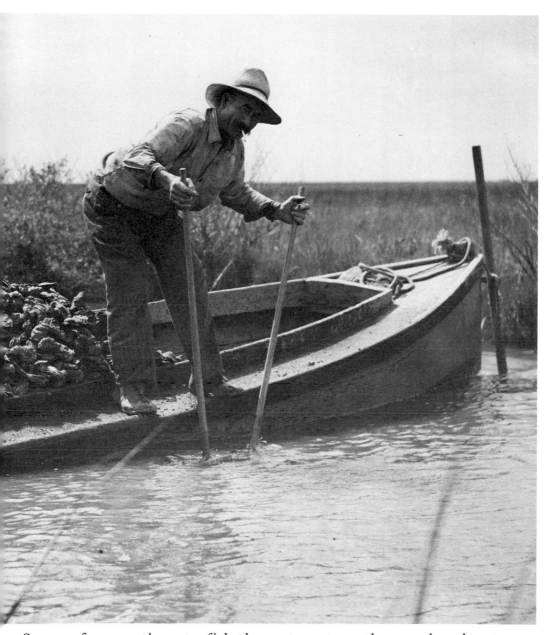

Some of us continue to fish the waters, trap the marshes, hunt woodlands and swamps.

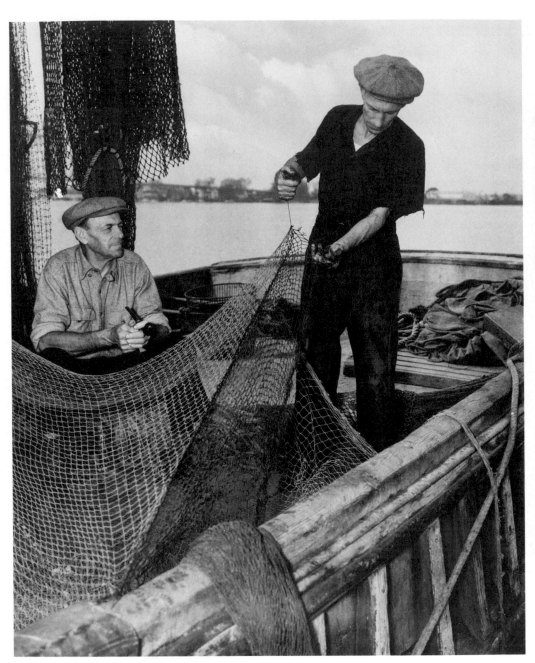

While we labor . . .

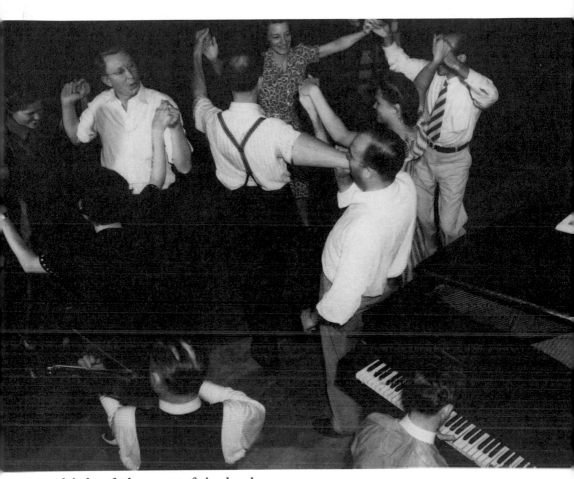

we think of the next fais do-do . . .

of a new homemade hat for petite Renée . . .

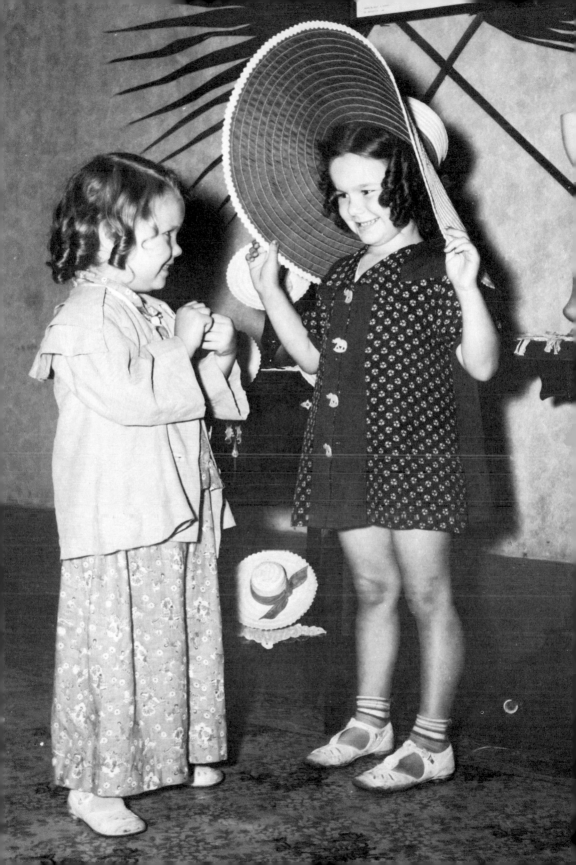

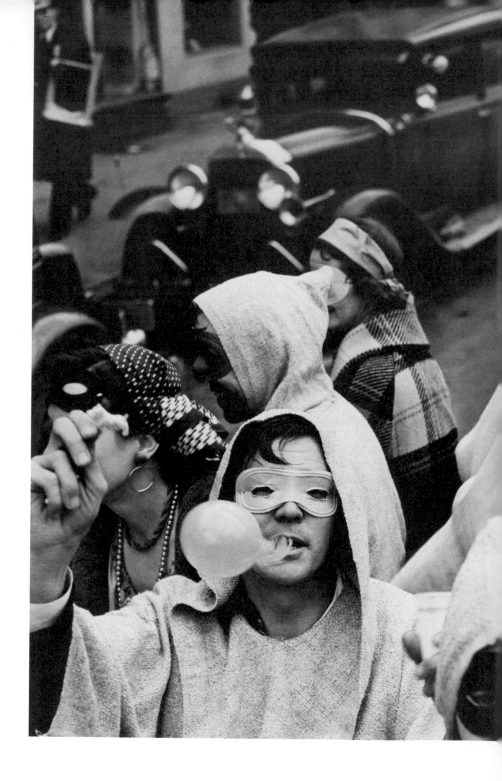

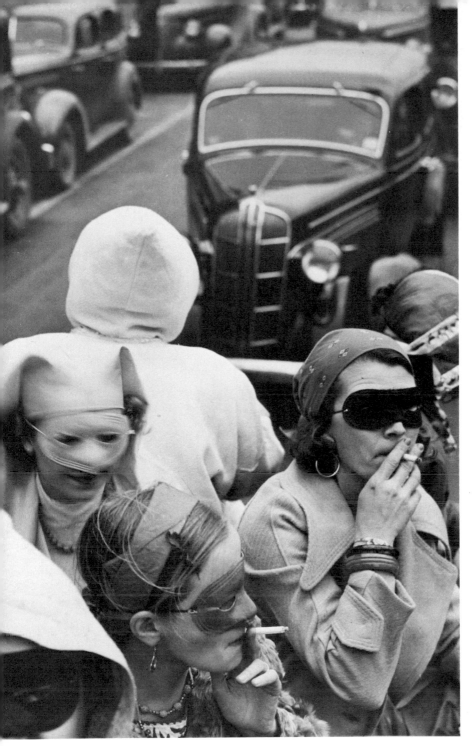

of a trip to La Nouvelle Orléans for the next Mardi Gras.

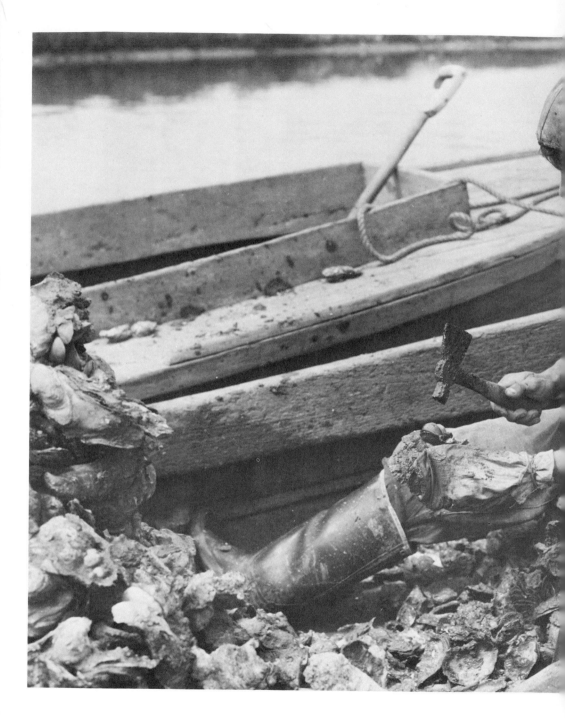

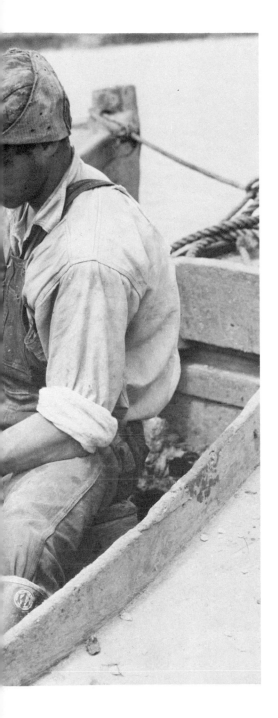

As we toil, we think of the next meal, a can of cold Dixie with a neighbor, duck season. The next bourée game. A gumbo filé with a few drops of Tabasco added for flavor and zest. Talk about good!

Yes, it is a joyous thing to be Acadian. Ask anyone who knows one. Better yet: Ask someone who is one. Our motto is "Laissez les bons temps rouler"—"Let the good times roll."

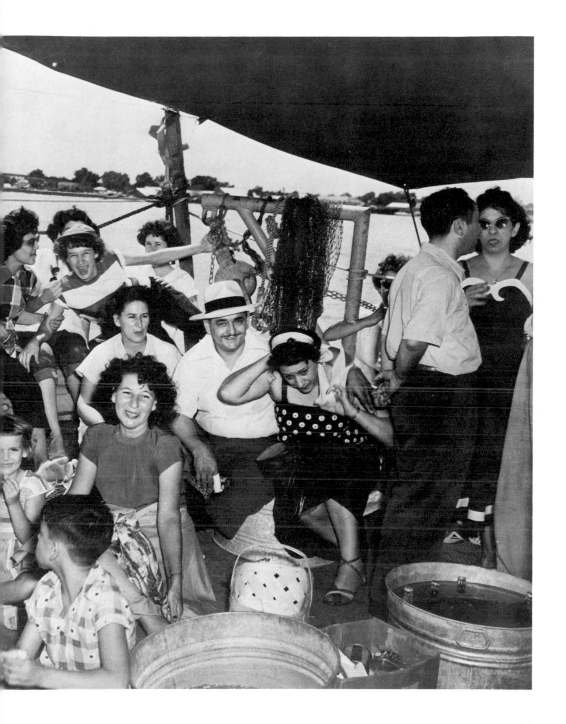

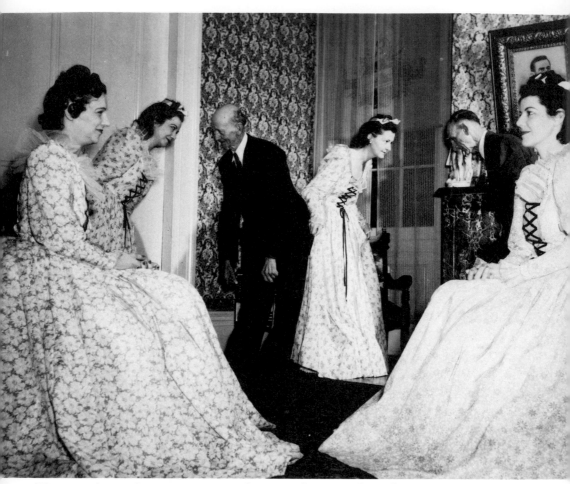

*We are Americans . . . proud ones, forever loyal to our great
country. But our spirit still remembers well that we were
French first, and Canadian second. How many people can
grow up experiencing a cultural legacy of three nations
flowing through their consciousness?*

We can . . . and it's exhilarating.

We are carefree Acadians . . . a little different, yes!

But vive la différence!

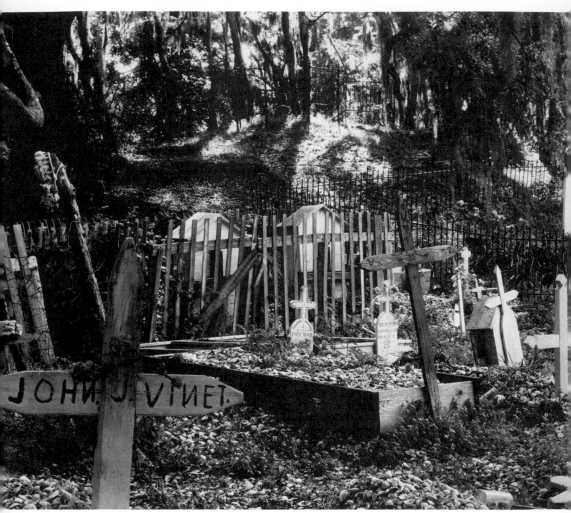

Vive also the memory of our fathers and forefathers who left us such a priceless heritage.

Epilogue

As a typical character in a Cajun story might say, "I bet dis is de firs' book you ever saw what has a beforeword and a behin'word, too."

Well, he might be right. But the epilogue is here for a good purpose. Many people will be reading this book while they are spending their first visit among Louisiana Acadians. So a few points about Cajun names may be both interesting and helpful in solidifying the new acquaintanceship.

The end sheets of this book deserve comment.

Inside the front cover and the back cover is a partial list of Cajun family names.

Please note that the preceding statement includes the word *partial*. We fully expect to receive calls and letters from Cajun people who can't find their names on the list. Some will complain that names are not spelled the way they spell theirs. If we missed your family name or your particular spelling, please forgive us.

From the list, it is probably apparent that Louisiana's people of French descent have the same family names as French people in Canada and in Europe. But a closer look at some of the names shows a few interesting differences.

First of all, some of the French names were Americanized as it became an economic necessity to speak English as well as French. Because Cajuns spoke French and thought in French, their English vocabulary was severely limited and a consequent handicap to their education. For years, Cajun children were forbidden to speak French on school grounds, and non-French-speaking teachers were recruited from out of state to come to Louisiana to teach Cajun children. These appointed "saviors" were responsible for Americanizing too many beautiful French names:

93

de Coteau became Hill, d'Edouard became Edwards, Meunier became Miller, and so on.

Mrs. Leona Martin Guirard of Saint Martinville, a foremost authority on Louisiana Acadians, believes the changing and shortening of some names was the fault of English-speaking Americans who could not pronounce the French names or write the French language. In writing out a check for a French employee, a clerk who knew no French would arbitrarily simplify the name. The Cajun, in endorsing the check, had to misspell his name so that it would match the spelling on the face of the check. Soon he did it automatically, and eventually recognized it legally as his own.

In a less noticeable fashion, many French names became Americanized orthographically, so to speak. The original French name may have had two or three parts, with small and capitalized initial letters, contractions with apostrophes, and such. But the Cajuns simplified much of that—in many cases disregarding all the small and capital letter distinctions and omitting the apostrophes.

Thus many people whose names originally were, for example, le Blanc or le Jeune, spell them simply Leblanc or Lejeune. Other Cajuns have kept the two words separated, but generally they capitalize both—Le Blanc or Le Jeune. A three-part name, de l'Aune, has become De Laune or simply Delaune.

Some Cajuns became carried away with the capital letter system. Even though they keep the apostrophes, they capitalize all the initial letters. For example, for some families the name d'Aquin has become D'Aquin, and d'Artois has become D'Artois. There are also variations such as Dartois, and in the case of the original French name l'Artigue, there now are L'Artigue, Lartigue, and simply Artigue. But no matter how the spelling may have been changed, all of the foregoing are good, solid Acadian-French names.

Pronunciation is something else. Among themselves, the Cajuns use purely French pronunciations for their names. But surrounded by "foreigners" like Texans on one side and North Louisiana and Mississippi "rednecks" on the other, the Cajuns have had their names mispronounced by experts. And they have learned to tolerate the strange pronunciations. ("Rednecks" is a term applied to farmers of North Louisiana and western Mississippi. As they till the soil, with bodies bent forward, the backs of their necks are exposed to the sun; hence the identifying name. Others say it's because dust from the red clay hills, blown by the wind, settled

on the sweaty necks of cotton pickers. Whatever its source, the term persists.)

Outlanders who haven't heard the French pronunciation of the name Bourgeois (pronounced Boorzh-wah) have quite a time trying to pronounce it correctly. They usually get something like Boor-go-wiss, instead. Though it may appear to rhyme with *tiger*, the name Viger is pronounced Vee-zheh.

A beautiful name like Shen-vair gets a pronunciation like Chee-nuh-vert from "foreigners," who see it spelled Chenevert. In English, the name Chenevert would be Greenoak, for chene - oak, and vert - green. English-speaking people generally try to make Chenevert into three syllables. They have even influenced many of the people in the northern part of Cajunland to pronounce the name Shen-uh-vair (with a slight "uh" sound in the middle), but actually it has only two syllables, *chene* and *vert*, properly pronounced Shen-vair.

Sometimes the Acadians played havoc with American and other "foreign" names. One German community in southwestern Louisiana originally was named der Ritter, German for "the Knight" (rider). When the Cajuns, who knew how to spell that name in their own phonetic way, moved in, the town officially took the French spelling and has been De Ridder ever since.

Because of the famous wines from Bordeaux, most Americans know the name is pronounced something like Bor-doh. Consequently they usually have no trouble with French names that end in -*aux*, which sounds like *oh*. Thibodaux is Tib-uh-doh, Boudreaux is Bood-roh, Breaux is Broh, and so forth. That leads up to an old joke that shows how well the Cajuns can spell in English:

Alphonse: 'Eh, Placide, dat's a nize dog you got dere. What you call him?

Placide: I call him Fido.

Alphonse: How come you give such a nize dog like dat a terrible redneck name like Fido?

Placide: 'Cause, man, it's so easy to spell: P-h-a-i-d-e-a-u-x.

But the "rednecks" have their problems too. Some time ago, a

fellow named Jack Lockhart moved from Shreveport, in North Louisiana, to Lafayette, the capital of Acadiana. He took no issue with the slightly French way people pronounced his name, but he was astounded when he began getting his mail addressed to Jacques La Carte.

One more observation is in order. Many people, Cajuns and "foreigners" alike, regret that a number of classical first names are passing from use. Catholic priests, educated in Europe and impressed with the Renaissance, enthusiastically suggested names of Greek philosophers and historians to Acadian parents for their children at baptism. Thus many Acadian children received names such as Pliny, Telesphor, Eusebe, Cleophas, Aristide, and on and on. But no more. Members of the older generation are a little wistful about the passing of such names, while the younger people are understandably delighted. But these names still find their way into Cajun humor, when they serve well to illustrate that a Cajun is pretty wise or a devilishly shrewd fellow when the situation presents itself, such as the old one about the Texas counterfeiters who one night mistakenly printed a whole batch of $18 bills.

"No need to worry," one of the Texans mused. "I'll go over to Southwest Louisiana and pass them off among those dumb Cajuns."

The next day he stopped at Telesphor Guirard's service station, located about fourteen miles and three pecan trees outside of Saint Martinville. He handed the proprietor a crisp, new, bogus $18 bill and asked for change.

Telesphor, who could kill at least two wild ducks out of every pair flying by, passed his keen eyes over the fake bill, and in loud, clear, nasal tones implored, "Mais, mon fran, how you want you change, huh? T'ree 6's, six 3's, or two 9's?"

Then there were Cleophas Lancon and Aristide Lavergne, who were driving from Carencro to Lafayette one Saturday afternoon to pass the good time away at Four Corner.

Cleophas glance at Aristide an say, "Hey, Aristide, stick you head out de glass an tole me if mah turn indication she work."

Aristide proceeded to put his Dixie beer on the floorboard and stuck his head out "all de way to his wais."

"Okay, Cleophas, turn you turn indication on."

Cleophas did, then inquired, "Does she works, Aristide?"

To which Aristide responded with a chuckle, "Yah, non. Yah, non. Yah, non. . . ."

Enfin, La Fin!

LABAT LABATUT LA BAUVE LA BELLE LABLE LA BODE LA BORDI
LABOULIERE LA BRANCHE LACAFFINIE LACASSIN LA CAZI
LA CHAPELLE LACHERY LACOMBE LACOSTE LACOUR LA CROIX
LAFARGUE LAFAYETTE LAFIELD LAFITTE LA FLAMBOISE
LA FLAMME LA FLEUR LA FONT LA FONTAINE LA FOSSE LA FRANCI
LA FRANCINE LA FRENIERE LAGARDE LAGER LAGREAUX LAGRON
LAGROUE LA HAYE LAICHE LAJAUNIE LA JOIE LALAND
LALUMANDIER LAMBERT L'AMBREMONT LAMOTHE LAMOUSIN
LANAUX LANCLOS LANDAICHE LANDRENEAU LANDRIEU LANDRY
LANGLINAIS LANGLOIS LANIER LANNEAU LANOUX LANPHIE
LANTHIER LAPEROUSSE LAPEYROLERIE LAPEZE LA PIERRE LA PLACE
LAPLANTE LA POINTE LA PORTE LA PRAIRIE LAQUE LAQUERRI
LARCADE LARGUIER LA RIVIERE LA ROCHE LA ROCHELLE LA ROSE
LARPENTEUR L'ARRIVEE LARTIGUE LA SALLE LASITER LASSAR
LASSEIGNE LASSERRE LASTRAPES LATIOLAIS LATOUR LAUDI
LAURENT LAURIER LAUVE LAUX LAVERGNE LAVILLE LE BEAU
LE BERT LE BLANC LE BOEUF LE BOURGEOIS LE BOYTEAUX
LE BRANE LE BRETON LECAMUS LECHIER LE CLERCQ LE COMPT
LE COQ LEDET LE DOUX LE DUFF LEFAN LEFEAUX LEFEBVRE
LE FORT LEGARDE LEGEAUX LEGENDRE LEGER LEGIER LEGLE
LE GRAND LE GROS LE JEUNE LELEAUX LEMAIRE LE MAISTR
LE MAY LEMELLE LE MIEUX LEMOINE LE NOIR LE RAY LE RO
LE ROUX LE RUTH LE SAGE LE SIEUR L'ESPERANCE LETEFF LEUZIE
LEVASSEUR LEVERETTE LEVERT LEVESQUE LEVRON L'HERISSO
LIEBERT LEIUX LIRETTE LIVAUDAIS LONGUEPEE LOQUE LORMAN
LOUDON LOUP LOUQUE LOUSTEAU LOUVIERE LUNEAU LUQUETT
LYON MABILE MADERE MAITRE MAJOR MALBREAUX MALLE
MELVEAU MANADIER MANCEAU MANUEL MARCAUS MARCEA
MARCELLE MARCHAND MARCOMBE MARIONNEAUX MARQU
MARQUETTE MARQUIS MARTIN MATHERNE MATTHIEU MAURI
MAYEAUX MEAUX MECHE MELANCON MELETIN MELIET MENAR
MERCIER MESTAYER MESTEPEY METZ MEUNIER MEURET MICHAU
MICHEL MICHELET MICHIARD MICHOT MILIET MINVIELLE MIRABEA
MIRE MIREMONT MOINIOTTE MOINOT MOISE MOLBERT MOLLER
MONCEAUX MONCERET MONEAUX MONET MONGEAU MONGE
MONIER MONISTERRE MONJURE MONSON MONTAGU MONTELEO
MONTET MOREAU MOREE MOREL MORIN MORISSE MORISSETT
MORLIER MORVANT MOUCH MOUHOT MOUILLE MOUISSET MOULI
MOULIS MOURE MOUROT MOUTON MUNSON NADEAU NAQUI
NARCISSE NAVARRE NEAUX NOEL NORMAND NORBERT OCTAV
OLINDE OLIVERE OLIVIER ORDENEAUX ORDOYNE ORGERON OUBR
OUFNAC OURS PAILET PAILLE PANQUERNE PARENT PASQUIER PATI
PATOUT PATUREAU PECOT PECQUET PECUE PEDEAUX PELICHE
PELLERIN PELLESET PELTIER PERAULT PERILLOUX PERQUE PERRI